Ben Shahn

VOICES AND VISIONS

Ben

Voices and Visions

EXHIBITION: September 18 – October 31, 1981

COMPILED BY: Alma S. King
Director, Santa Fe East

GUEST COMMENTARIES BY: John Canaday
Martha Fleischman
Dr. Kenneth Prescott
Jacob Schulman

santa fé east ™ Santa Fe, New Mexico

FIRST EDITION

Book Design: Alma S. King, Director
 Santa Fe East Gallery
Book Production: Sunstone Press
 Mina Yamashita, Art Director
Printed in the United States of America

Kind permission has been obtained from
ALFRED A. KNOPF, INC., to reprint the excerpt from
WHAT IS ART? AN INTRODUCTION TO PAINTING, SCULPTURE AND
ARCHITECTURE, by John Canaday.
Copyright © 1980.

Our special thanks and acknowledgement for materials
contained in this catalogue to:
The Estate of Ben Shahn and
Kennedy Galleries, Inc., New York, New York.

Library of Congress Number for:

BEN SHAHN: Voices and Visions.
 Santa Fe East Gallery.

LC 81-14432

ISBN: 0-86534-004-8

Published in 1981 by Santa Fe East Gallery
 200 Old Santa Fe Trail
 Santa Fe, New Mexico 87501

CONTENTS

COLOR PLATES

159424

REPRODUCTIONS

N.B.
A complete exhibition listing of works displayed
and for sale is available upon request.

BEN SHAHN: VOICES AND VISIONS

santa fé east ™ is most honored to bring to Santa Fe the work of internationally renowned artist Ben Shahn. The exhibition "Ben Shahn: Voices and Visions" features over seventy works and encompasses the entire spectrum of Shahn's artistic genius. We are pleased to have several important portraits from the Dreyfus series of 1939 which marked the emergence of Shahn as a mature artist, intent on interpreting the social ills of the world through strong artistic statements. Represented in the show are many of the themes and subjects central to Shahn's work: The Sacco and Vanzetti case, the Depression, unemployment, prison conditions, Nazi brutality, politics, the Lucky Dragon disaster, science, the Atomic Age, brotherhood, equal rights, religion, love and beauty.

Ben Shahn had the ability to work in almost any medium using a diversity of styles which are richly demonstrated in this comprehensive exhibit. These include gouache, watercolor, brush and ink, tempera, serigraphy, lithography and gold leaf. Shahn was a talented photographer, adept in capturing the human condition, and this talent is well represented in the exhibit, as are his creative skills as a muralist, portraitist, calligrapher and illustrator.

Dr. Kenneth W. Prescott, personal friend of the artist and recognized authority on Shahn's artistic accomplishments, is the Guest Curator of our exhibit. He has devoted his special understanding of the artist and his works to the organization of this comprehensive and inspirational exhibition.

"Ben Shahn: Voices and Visions" is a visual experience of the ideals, hopes, fears and dreams of Ben Shahn, a great artist who expressed the conscience of modern man.

ALMA S. KING
Director, Santa Fe East

10

Ben Shahn's life typifies the mythology of the American dream, that hard work combined with God-given talent will bring success within the reach of nearly every man. To my knowledge, Shahn never entertained any boyish dreams of becoming President of the United States, but as a youth he wanted to become a master artist, and so he did. One of the great American artists of the 20th century, he enjoyed acclaim as well as controversy and, especially during his later years, received a recognition that was worldwide. His work, lyrical and poignant in whatever medium he chose to work in, is an illuminating testimony to the interaction of the artist and the changing society in which he lived for some seven decades (1898–1969).

The first eight years of Shahn's life were enriched by the old world culture of Kovno, Lithuania, as experienced in the context of a religious Jewish family. His early "schooling" was mostly confined to studies of the Bible, whose world of verse and music awakened his sense of beauty and rhythm, and whose colorful characters left an indelible impression on the young boy. Etched in his mind were also vague memories of small towns and a landscape where nature's wildlife and flora intermixed with the rewards of man's labor as manifested in undulating fields of grain.

Images emerging from memories of these early years, transformed by the patina of passing time, are seen in the work of his late mature years. But it was the subject matter, drawn from his experiences in the new world, which most profoundly influenced his oeuvre.

Ben Shahn immigrated to this country with his parents in 1906. They settled in Brooklyn and, with others from the old world, struggled with a new language and strange customs. Ben came from a family of craftsmen, woodworkers on his father's side and potters from his mother's. As a child he had enjoyed drawing and lettering and it seemed natural for him to be placed as an apprentice, at the age of fourteen, in a Manhattan lithography shop. There he worked by day, leaving the evening hours free for his high school education back in Brooklyn. From this apprenticeship, his interest in lettering would in time blossom into a richly varied calligraphic skill that found expression in his work from that time on.

Reared in a ghetto where waves of new immigrants struggled for survival, Shahn became an acute observer of the interplay of conflicting forces in society. Both as a son of "foreigners" and as a member of a minority group, his point of view — the outsider's — was not unlike the one seen through the right-angle viewfinder which he would later use in his career as a photographer. His sentiments would invariably rest with the underdog, and while the protagonistic stance taken in his early manhood mellowed considerably through the years, his social conscience was never put to rest. His brush expressed his mental agitation and indignation with forces that trampled on the rights of man as he perceived them. Whatever criticism that could be leveled at this artist, he could not ever be described as neutral and aloof. Indeed, the story of his life as told in his pictures, is one of a sensitive, educated and brilliant man, quick to respond to the social, cultural

and scientific environment around him as well as to the world of the past as perceived by him in literature, music and the visual arts.

This brief essay will concern itself with some of the key moments in Shahn's artistic career, as they are revealed by selected works in this exhibition. Following enrollment in New York University and the National Academy of Design, New York City, Shahn married and with his wife traveled to Europe and North Africa, first in 1924-1925 and then in 1927-1929, there to study first hand the art treasures of ancient and more recent times.

In Paris, during the first trip, he read an account of the historic Dreyfus case and was struck by the injustice and prejudice attached to this tragic event. At the turn of the century, international attention had been focused on the trial and conviction of the unjustly accused Dreyfus who, only after a lengthy period of disgrace and imprisonment, finally had received a pardon. Back in the United States, Shahn decided to, as he said, "...do some exposition of the affair in pictures." He presented the main participants in a simple and forthright manner and underneath the portraits, in his "best lithographic script," identified them by name and, in a few instances, by the role they had played. *Georges Picquart* (Cat. No. 3) of 1930 shows the colonel who, as head of the army's information branch, discovered the evidence which was the key to proving the eventual innocence of Dreyfus. The famed author Emile Zola had championed the cause of the

accused to such an extent that he found it advisable to flee the country for a period. The *Portrait of Emile Zola* (Cat. No. 2), 1932, and the Picquart portrait both exemplify a new, personal style that marks a shift from Shahn's painting of the twenties when he was greatly influenced by the European modern masters.

On the second of his European trips, he observed from the window of his Parisian hotel a street demonstration, protesting the alleged injustice which had resulted in the conviction and subsequent execution in 1927 of two Italian-Americans, Nicola Sacco and Bartolomeo Vanzetti. The trials, begun in 1920 and attracting international attention, had in common with the Dreyfus case the prevailing public opinion that prejudice had played a major role in the conviction. In 1931, Shahn set out to portray the principle characters and events related to this case. In 1932, the Downtown Gallery, New York City, exhibited the Sacco and Vanzetti series of some twenty-three pictures, which Shahn had painted over a seven-month period. The unqualified success of this exhibition, added to the reception given the Dreyfus series, reinforced the artist in his conviction that his direct style and emotional involvement with the subject matter, while running contrary to the contemporary avant-garde trends of disengagement, communicated to the audience what he as an artist and social being wanted to convey. It spearheaded a life-long interest in expository painting, much of it focusing on societal issues. *Witness Enrico Bastorie* (Cat. No. 15), 1931-32, a portrait of one of the witnesses in the trial, is based on a newspaper photograph. Shahn's *Portrait*

of *Sacco and Vanzetti* exists in several media. Included in this exhibition is a serigraph, *Portrait of Sacco and Vanzetti* (Cat. No. 12) of 1958, based on an earlier drawing and painting.

Encouraged by his friend, the famed photographer Walker Evans, Shahn began in about 1933 to photograph street scenes in New York City, many of which became references for subsequent paintings, drawings and prints. *Seward Park, New York City* (Cat. No. 68) of 1933, for example, is directly related in composition and subject matter to his first print, a lithograph of 1936, similarly titled *Seward Park. Seurat's Lunch* (Cat. No. 73), mid-1930s, is the source for his 1939 painting of the same name. The *Blind Accordian Player* (Cat. No. 71) was utilized by Shahn in his 1945 painting with this title. Many of the photographs in this exhibition, each taken by the artist, can be related to subsequent works of art.

The several studies for a Riker's Island Prison mural (Cat. Nos. 22, 23, 24, 25, 26 and 27) are from a Shahn sketch book of 1934-35. They originated as he and a fellow artist, Lou Block, visited the prison to talk with the prisoners and to document the conditions in pursuit of material intended for a prison mural. The commission fell through and all that remains from months of study are the sketches from his notebook.

Also in the thirties, from 1935 to 1938, Shahn traveled as a photographer for the Farm Security Administration, documenting aspects of rural and urban life. The two paintings, *Ask the Farmers*

(Cat. No. 31) and *Farmer and Son* (Cat. No. 28), both c. 1936, have their source in his experiences and photography of this period.

Shahn's interest in murals extended throughout his life and he executed them in various media including fresco, mosaic, oil painting and stained glass. In this exhibition are two studies for murals in the Federal Security Building, Washington, D.C. (Cat. Nos. 18 and 19) both of 1940-42.

Shahn's paintings related to World War II reflect his personal anguish for the human tragedies and concern for the art and architectural monuments of the Europe he had known and come to love in the twenties. In the main, they deal with death, destruction and devastation, but in some hope is also present. *Concentration Camp* (Cat. No. 21), 1944, depicts a Nazi prison camp where human beings are herded like cattle behind a barbed wire enclosure, testifying to the beastliness which exists among men.

In 1957, Shahn made a series of drawings to accompany an article for *Harper's* magazine, written by the atomic physicist Ralph E. Lapp about the Japanese fishing boat, the Lucky Dragon, which had strayed into the fallout from the United States hydrogen bomb test on Bikini Atoll in the Pacific. This story was published in book form in 1965 as *Kuboyama and the Saga of the Lucky Dragon* with text by Richard Hudson. Shahn prepared a series of narrative paintings for this book which are reproduced

in color. One of these, *The Lucky Dragon* (Cat. No. 8) of 1960-61, shows the dying radioman of the fishing vessel. Seated on a hospital bed, his skin turning black from radiation, he holds a card on which Shahn's lettering describes the tragic circumstances. The calligraphy and the use of a message within the picture are familiar conventions in Shahn's oeuvre. Four of the drawings, prepared for the *Harper's* article are included here (Cat. Nos. 32, 33, 34 and 35), each of 1957. In addition, the 1961 watercolor, *Dove, One of a Score* (Cat. No. 47), is the artist's version of the traditional release of doves at the conclusion of a Japanese burial ceremony, in this case Kuboyama's.

Other works in this exhibition illustrate Shahn's versatility as an artist and his wide-ranging interest in the problems of society; others reflect his Jewish background and, as time went on, his increasing interest in religious themes. The exhibition as a whole offers the viewer an opportunity to judge, in a limited way, the success of Shahn as an artist and to examine some of the episodes from recent history as seen and interpreted by Shahn. Not one book or one exhibition can adequately present the importance of this American artist, whose greatness and position in the history of art can only be revealed in a large body of the works themselves; yet, each exhibition and each piece of literature help to document and illuminate his career. Santa Fe East is to be congratulated for playing its role in this important process.

DR. KENNETH W. PRESCOTT
University of Texas at Austin, June 1981

MY FIRST ACQUISITION

My first acquisition of a painting, Ben Shahn's *Concentration Camp*, was made over thirty years ago. Since then, I have been obsessively engaged as a collector of works of art by Shahn and by other first generation Americans. These were painters and sculptors who created out of the dynamics of their time with a sense and spirit of our country, but which were infused with influences of the artists' particular settings embracing an Eastern European Jewish background. It was an experience I shared with these artists and my collection gave expression, to borrow the words of Rilke, to "all the memories themselves...that have turned to blood within us...; nameless and no longer distinguished from ourselves."

In this period, I never missed an opening of Ben Shahn's regular exhibits at the Downtown Gallery, which provided opportunities to visit with Shahn and to share the joy he experienced in presenting his new creations. In 1965 and for three years thereafter, I was privileged to be involved with Ben Shahn in arranging for a mosaic mural of *The Passion of Sacco and Vanzetti* to be installed on the campus of Syracuse University. It was a great moment for me, for it bound me to Shahn in an enriching, aesthetic experience, with a creation of what was very best in him and which had its roots in his remorseless unveiling of injustice.

How clear, then, the poetic view of the Hassidic Rabbi Nachmann became to me for he taught: "Just as the hand held before the eyes conceals the greatest mountain, so this petty earthly life

conceals from view the vast light and mysteries of which this world is full, and he who can withdraw it from his eyes, as one withdraws the hand, will behold the great light of the innermost world." A personal vision applied to the collecting of art has not only been a cherished experience for me but, also, brought me to behold the great light of the innermost world.

JACOB SCHULMAN
Gloversville, New York, June 15, 1981

THE DRAWINGS OF BEN SHAHN

Of the major works of Ben Shahn, a significant number are drawings. The highly charged, "barbed wire" line is characteristic of his mature style; its evolution and increasingly important role illuminates many broader aspects of the artist's career.

Shahn had a natural inclination to draw. He began to display his talent as a boy by drawing likenesses on the sidewalks of Brooklyn for his own amusement, and for the command performances of local bullies. Even as a very young artist, Shahn placed a great deal of importance on the nature and quality of the drawn line, as it was to be fundamental in giving form to his most profound expression. A love for all kinds of calligraphy developed, in part, as a result of rigorous training he received as a lithographer's apprentice. On the other hand, he rejected the narrow teachings expounded in the academic drawing classes and preferred to pursue his own style through experimentation.

In the 1920s, Shahn continued to search for meaningful subjects in his art and an original form that this would take, but the work produced in France still showed the pervasive grip of Matisse and Cezanne. It seemed to be his admiration for the work of Giotto, with its directness and visual clarity, that would effect the greatest influence. The early 1930s demonstrated a breakthrough in Shahn's work which was at once stylistic and philosophical, as he turned to subjects of moral outrage and protest. Forms became broadly simplified and more two-dimensional.

From this point Shahn launched into the early part of his mature style for which he is known, although the few drawings created in the 1930s and early 1940s are essentially preparatory studies. Shahn's most important drawings of this period were the giant mural sketches, which delineated basic forms and served as a working guide for the actual execution of the mural.

Shahn never considered one medium to be more important than another as each has its own capabilities and limitations. This belief enabled Shahn to produce numerous brush drawings as "finished" works of art, which are considered as important as many temperas. In the last twenty years of his career, drawing was the cornerstone of Shahn's artistic expression. Drawing became interwoven with painting: a linear framework often lying at the heart of the composition, or a broad area of color invigorated by powerful black lines. Also, Shahn continued to produce cycles or paintings (a kind of visual story-telling) but now, a new visual rhythm was created by interspersing small, intimate drawings with the paintings. His series *The Saga of the Lucky Dragon* (Cat. Nos. 32, 33, 34 and 35) is the most famous example of this treatment.

As a keen observer of humanity, Shahn developed into a supreme painter of portraits. In his drawings, with few lines only, he presented the quintessence of personality; the steadfastness of Martin Luther King, the intellect of Albert Einstein (Cat. No. 38) and the humanity of Gandhi (Cat No. 37). As a brilliant satirist, Shahn gave momentum to his own political opinions, drawing

biting caricatures of public figures such as Joseph McCarthy and Barry Goldwater (Cat. No. 36).

Shahn's interest in portraying people always remained central in his drawings as in his paintings, but he believed that human nature and society as a whole could be expressed by revealing aspects of its architecture, its legends, its inventions. Loneliness and despair within a mental hospital is evoked deeply through his depiction of an empty corridor comprised of a few narrow lines. TV antennae, roller skates and shopping carts are transformed into emblems of twentieth century man, and the interplay of lines found in these objects made them naturally interesting to Shahn for subjects of drawings. In addition, Shahn's deep interest in Chinese calligraphy produced drawings of even more fluidity and spontaneity in the 1960s (Cat. Nos. 41, 42 and 43).

Being a man of great intellect, many projects involving book illustrations were of interest to Shahn. He saw the opportunity to illuminate a literary work further by bringing to it his own personal vision. These drawings are prized as individual works of art, even independent of their original context.

Shahn was in the midst of an entirely new artistic phase at his death in 1969. Virtually all of his final projects display the domination of his drawing style, specifically the *Hallelujah Portfolio* with its lyrical calligraphy and exuberant musicians. His monumental brush drawings of these figures,

which were to have become the basis of a mural, are his last and perhaps his most beautiful drawings ever. Shahn's late works were less specific and reflected more universal and deeply symbolic themes. In order to communicate this complexity, Shahn continued to simplify his art to its very essence, letting the energy of his lines speak. Had he produced nothing but a lifetime of drawings, Ben Shahn still would have held his place among the twentieth century of geniuses of American art.

MARTHA FLEISCHMAN
Kennedy Galleries, Inc., New York, New York

Passion of Sacco & Vanzetti compared to Botticelli's Calumny

Although Botticelli is known to have come under Savonarola's influence, it is not likely that *Calumny* is a reference to the martyred priest's trial, conviction and execution, since most scholars believe that the picture was painted before Savonarola was executed in 1498. But the intensity of the painting does suggest an anguished protest against the spirit of the witch-hunt, the punishment of innocent people who are sacrificed to public hysteria. Therein lies its parallel to the twentieth-century painting we are comparing with it, a picture speaking of the trial, conviction and execution of two men, Nicola Sacco and Bartolomeo Vanzetti.

As in the case of Savonarola, the guilt or innocence of Sacco and Vanzetti was the subject of vehement controversy. The painter believed that they were the victims of a miscarriage of justice. We are not balancing the scales here, but are examining the protest made in pictorial form by an artist in the light of his own belief, in order to compare it with a similar subject approached in a different way.

Botticelli's painting accuses the Florentine government of ignorance, suspicion, envy, calumny, fraud and deception; depicts it as unworthy of the crown and scepter of authority; proclaims the victim's innocence; and prophesies the city's remorse—all this in allegorical concealment. The modern painting makes parallel accusations with no effort whatsoever at disguising the message. In the *Passion of Sacco and Vanzetti* all subtleties and indirections are abandoned for an

uncompromising indictment.

Nicola Sacco was a fish peddler and philosophical anarchist; Bartolomeo Vanzetti a shoe-factory employee and radical agitator. In 1920 they were accused of killing two men in a payroll holdup at South Braintree, Massachusetts, and found guilty. But for six years liberals everywhere campaigned for their release on grounds that prejudice had convicted the men; essentially, that they were being convicted as an anarchist and radical agitator rather than as killers in a holdup.

A series of sensational appeals culminated in the appointment of a committee of three, headed by President Lowell of Harvard and including the president of Massachusetts Institute of Technology and a former judge. The opinion of this committee was that the guilty verdict should be sustained. Sentence of death on Sacco and Vanzetti was carried out in the prison at Charlestown, Massachusetts, on August 22, 1927. But a large body of considered opinion continued to believe the two men innocent.

Calumny and the *Passion of Sacco and Vanzetti* have a very close similarity of pictorial procedure beneath their primary differences of style. In the *Passion of Sacco and Vanzetti* the victims are not shown dragged naked to false judgment but are revealed in their coffins after execution. It does not take a great stretch of the imagination to associate the half-caricatured figure in academic cap

"In *the* PASSION OF

SACCO AND VANZETTI

all subtleties and indirections

are abandoned for

an uncompromising indictment."

and gown with Botticelli's figure of Calumny. He is flanked by two top-hatted figures holding lilies in their hands. They are certainly parallels to Fraud and Deception, the female figures who twine roses in Calumny's hair. The roses and the lilies borne by the top-hatted figures are the same false symbols of purity.

The parallel continues. Botticelli's unworthily crowned and sceptered false Judge is repeated in Shahn's painting by a framed portrait of the sentencing judge in the Sacco-Vanzetti case, his hand raised in a gesture that combines the oath of truth and a gesture of benediction, both of which are desperately ironical. This portrait hangs in the hall of a neo-classical court building corresponding to Botticelli's allegorical Renaissance palace. The only element without correspondence is the group of Remorse and Truth—if, indeed, the lamp in the upper left corner of the modern picture is not intended to be some such reference.

The...pictures we have seen so far have taken their subjects from specific instances of social cruelty or injustice. In varying degrees they accepted or overcame the limitation that can prevent this kind of picture from being an independent expression—the limitation, that is, of the observer's being dependent on knowledge of the specific event for full understanding of the picture's meaning.

Even without this knowledge, even if we are left to find for ourselves their general sense, these pictures are works of art of interpretive power or, at least, of curious fascination.

JOHN CANADAY

from *What is Art? An Introduction
to Painting, Sculpture and Architecture.*
Alfred A. Knopf, Inc., New York, 1980.
Reprinted by permission of the publisher.

Ben Shahn used the camera to record the immediate event, spontaneously and unobtrusively. He believed in the camera's ability not only to record but also to interpret and express more than the human eye is capable of doing.

When Shahn began photographing, he was primarily interested in people and their reactions. His intention was to capture the split second action as a reference or a model for future paintings. Consequently the content of the photograph – the image – was more important than the technical aspect or quality of that image. As he began photographing for the Resettlement Administration, his intent was still to capture the human action or condition, but now he felt there was a moral purpose – helping the underprivileged. And again, it was the content of the image that mattered.

Photographer Walker Evans shared a flat in Greenwich Village and a cottage at Truro on Cape Cod, and Evans taught Shahn many of his photographic skills. Shahn received his first 35mm Leica (from his brother in payment of a wager) the day Evans was leaving on an assignment in the Caribbean. As he walked out the door, Evans shouted out instructions to the eager new photographer: "F9 for the bright side of the street, F4.5 for the shady side!" Shahn followed Evans' instructions literally, up one side of the street and down the other.

Ben Shahn preferred the convenience and compactness of the 35mm camera to the staged and

manipulative qualities of the bulky view camera. For even more anonymity he used a right-angle viewfinder, which often resulted in chopped off heads and unposed composition. His preference for not using a flash attachment was yet another indication of his argument against the camera's intrusion into nature.

The majority of his photographic efforts were concentrated between the years 1932–1938. The first few years were spent photographing New York: its people, conditions and events. In 1934-1935 Ben Shahn and Lou Block photographed street life and prison conditions in preparation for the projected murals for Rikers Island Penitentiary. They covered New York's lower East Side, labor demonstrations and New York State Prisons.

In 1935-1936 Ben Shahn worked for the Resettlement Administration as a photographer on the Special Skills staff where, under the direction of Columbia University historian Roy Stryker, he helped create the Resettlement Administration File. Shahn contributed thousands of photographs to this documentation of poverty in rural America. From 1935 to 1938 Shahn was employed by the Farm Security Administration as an artist, designer and photographer. It was in this capacity that he took a series of photos documenting Ohio rural and small town life.

Ben Shahn the photographer contributed greatly to the evolution of Ben Shahn the artist. Beyond

the immediate effect of translating images from film to paintings, the years of travel, observation and revelation which he experienced transformed the philosophy of the artist and the man. The belief in "social realism" melted away and was replaced by a new belief. The style, content and spirit of Ben Shahn's later work reveals a new and mature stance and a belief in "personal realism" — the photographer, the artist and the man were one.

ALMA S. KING
Director, Santa Fe East

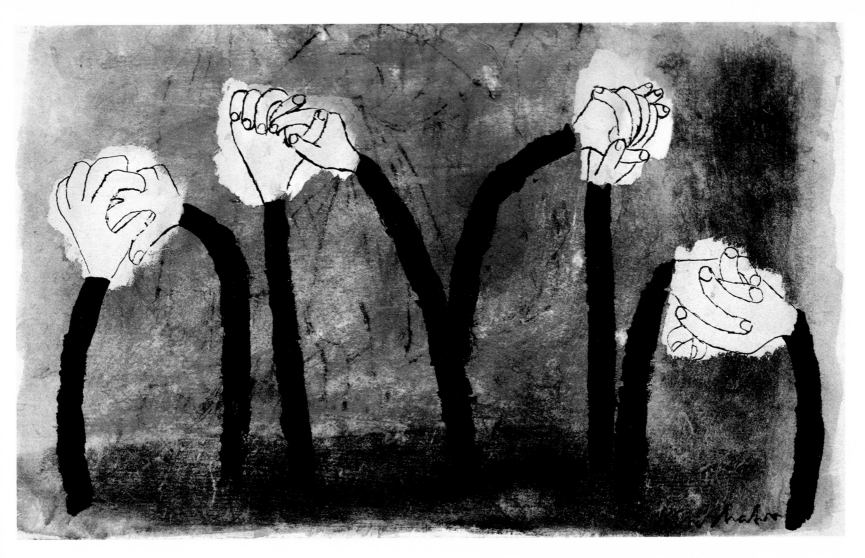

1 / *Love Sonnet: I Cry Your Mercy...* c. 1964
Gouache on paper, 7¾ x 12¾ inches

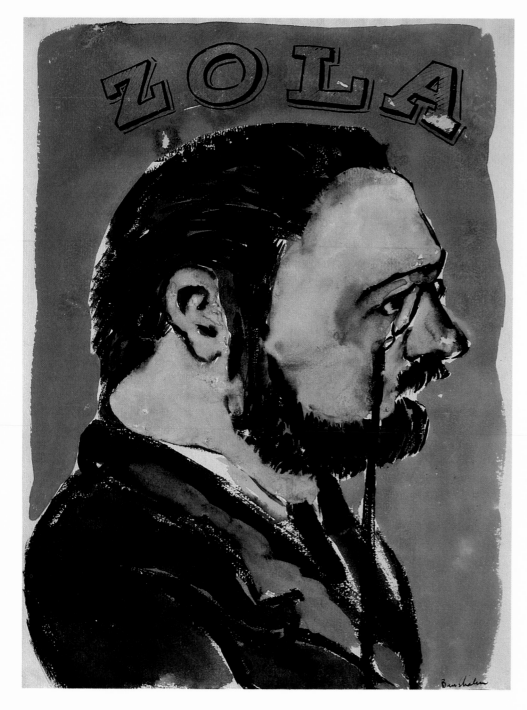

The Dreyfus Affair began in 1894 as a case of treason in the French military and ended in 1906 as a uniting factor for the French political left wing. Captain Alfred Dreyfus, a French general staff officer, was convicted of treason and sentenced to "degradation and transportation" for life. He spent the next twelve years on Devils Island in solitary confinement. Dreyfus protested his innocence, but public opinion generally applauded the conviction of a wealthy Alsatian Jew at this time of monarchist and Catholic political dominance.

In 1896 Colonel Georges Picquart discovered evidence indicating Major Ferdinand Esterhazy as the true author of the traitorous letter that convicted Dreyfus. This news split the country into two irreconcilable factions. Picquart was silenced by military authorities, and Esterhazy was tried and acquitted in a matter of minutes. Emile Zola, a leading supporter of Dreyfus, published a letter to the President of the French Republic charging the judges of the trial with obeying orders from the War Office to acquit Esterhazy. Zola was subsequently tried for libel and sentenced to jail, but he escaped to England.

For a decade the violent partisanship which developed over the Dreyfus Affair dominated French life. However, the personal fate of Captain Dreyfus was of little concern to either faction, and Dreyfus remained in solitary confinement on Devils Island. Following the suicide of Colonel Henry, who had forged the evidence against Dreyfus, and the flight of Esterhazy, it became apparent that the Dreyfus sentence would have to be revised. To the utter indignation of the world, Dreyfus was found guilty with extenuating circumstances and sentenced to 10 years in prison.

2 / Portrait of Emile Zola, c. 1930
 Watercolor on paper, 16 x 12 inches

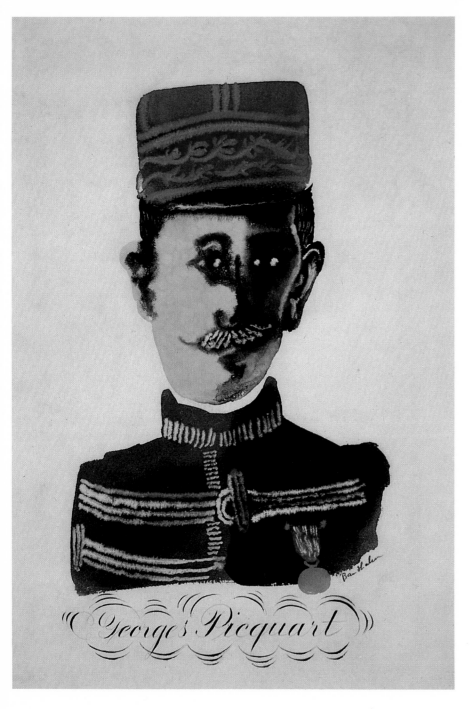

Georges Picquart

In 1906, President Emile Loubet pardoned Captain Dreyfus who was then reinstated as a Major and decorated with the Legion of Honor.

Ben Shahn studied the accounts of the Dreyfus Affair during his first trip to Paris and continued to study them when he returned home. He was horrified by the injustice and prejudice of the case and painted a series of thirteen gouaches depicting its chief participants. Thus began his new, highly personal expression which marked the shift from a European dominated style to a more direct approach and emotional involvement in subject matter.

3 / *Georges Picquart*, 1930
Gouache on paper, 14¾ x 10 inches

ON PAGE 44: DEWEY AND VENTRILOQUIST: ▶
Thomas E. Dewey and Harry S Truman became victims of Shahn's satirical brush several times, including VANDENBERG, DEWEY AND TAFT *(1941),* TRUMAN AND DEWEY *or* A GOOD MAN IS HARD TO FIND *(1948) and the painting on page 44.*

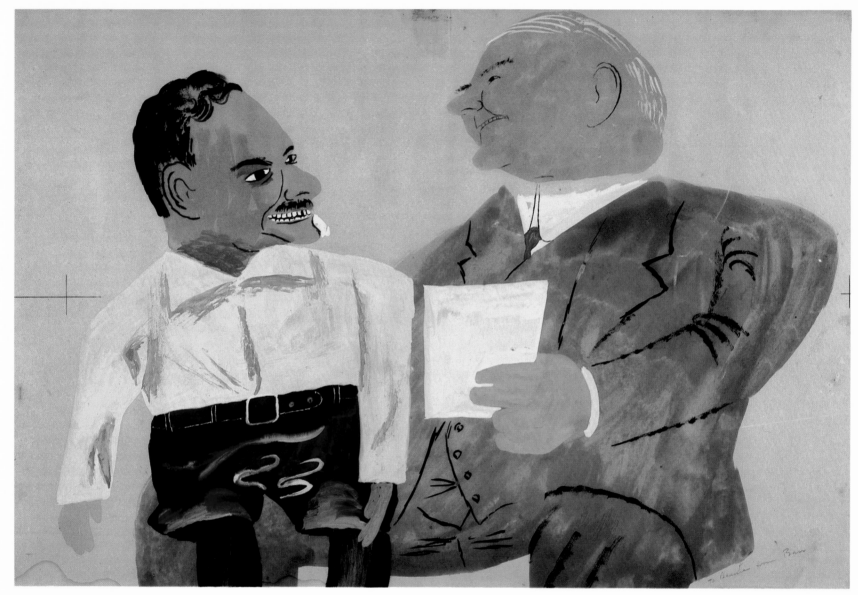

4 / *Dewey and Ventriloquist,* 1948 Gouache on paper, 16 x 23¾ inches

5 / *The Great State of Wisconsin*, 1937 Tempera on board, 15 x 18½ inches (Study for HEW Building, Washington, D.C.)

6 / *Atlantic City*, 1947 Tempera on academy board, 24 x 32 inches

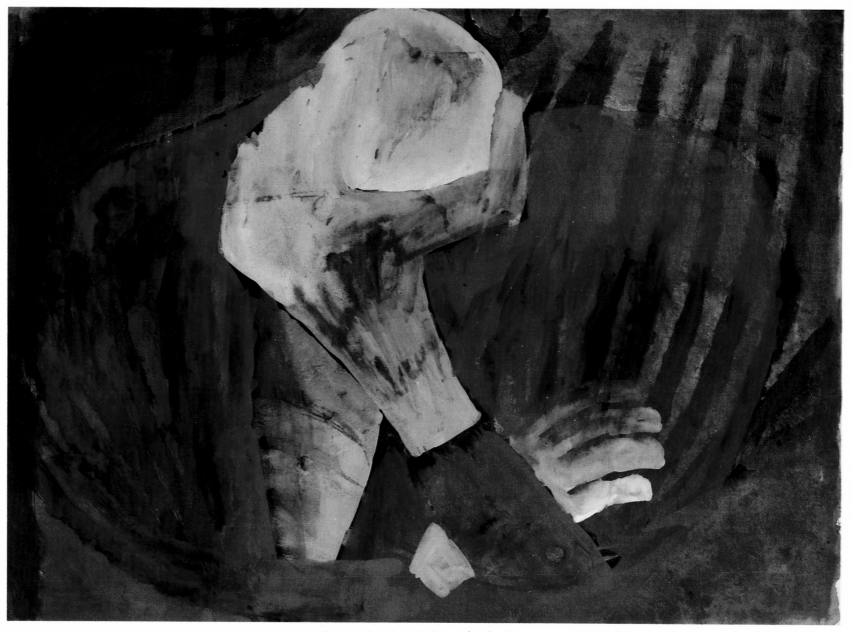

7 / Melancholia, 1953
 Gouache on paper, 19½ x 26½ inches

A similar attitude and mood of anguish is found in WARSAW 1943 *(1963), a serigraph commemorating the courage of the Warsaw Jews in their futile resistance to Nazi forces.* BESIDE THE DEAD, *a lithograph from the Rilke Portfolio, is a slimmer, revised interpretation of* MELANCHOLIA.

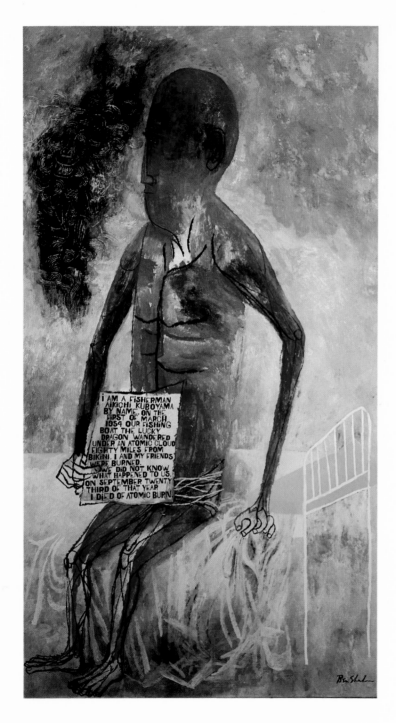

Shahn completed in 1962 a series of paintings inspired by the 1954 disaster that befell the Japanese fishing trawler FUKURYU MARU or the LUCKY DRAGON. While fishing for tuna and shark off their home port of Yaizu, Japan, the boat drifted toward Bikini Atoll where the United States was testing a new H-bomb. The boat was covered with radioactive ashes and the crew members suffered from radioactive poisoning. The radio operator, Aikichi Kuboyama, died seven months later after an agonizing illness. Kuboyama and his crewmates did not know the danger or cause of the rain of ashes, and Kuboyama had unknowingly slept with the lethal ash covering a parcel tucked under his pillow.

8 / The Lucky Dragon, 1960
 Tempera, 84 x 48 inches

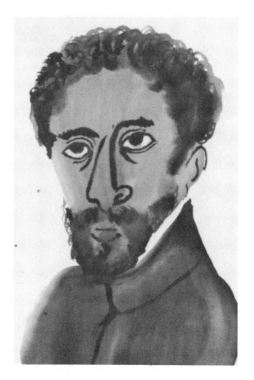

10 / *Haile Selassie*, 1935
Gouache on paper,
9¾ x 6 inches

9 / *Cafe Scene in Tunis*, 1928
Watercolor on paper, 19¼ x 13¾ inches

There are very few works which directly reflect Shahn's European and African visits in 1925 and 1927. CAFE SCENE IN TUNIS *(1928) is typical of the style of other paintings such as* SEATED WOMAN *of the same year. In these works a strong French influence is evident.*

11 / *White Camels*, 1943
Gouache on paper, 6 x 5 inches

WHITE CAMELS *was painted in 1943, fifteen years after his African trips, for the Container Corporation.*

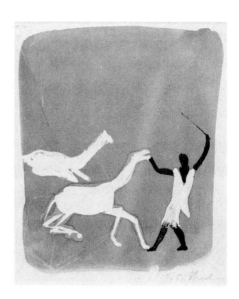

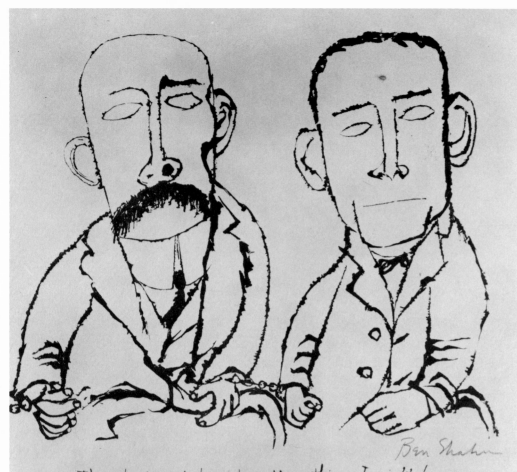

If it had not been for these thing, I might have live out my life talking at street corners to scorning men. I might have die, unmarked, unknown a failure. Now we are not a failure. This is our career and our triumph. Never in our full life could we hope to do such work for tolerance, for joostice, for man's onderstanding of man as now we do by accident. Our words - our lives - our pains nothing! The taking lives - lives of a good shoemaker and a poor fish peddler - all! That last moment belongs to us - that agony is our triumph.

12 / *Portrait of Sacco and Vanzetti*, 1958
Serigraph, 15 x 20 inches

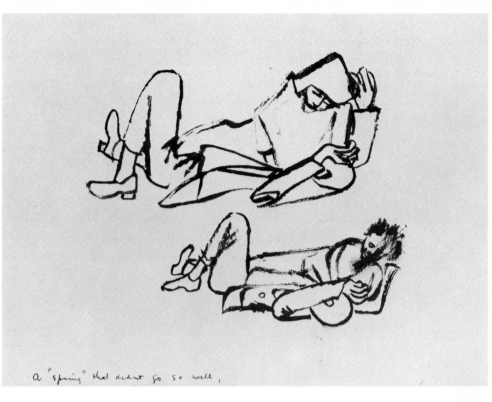

13 / A 'Spring' That Didn't Go So Well, c. 1947
Ink and brush drawing, 9 x 12 inches

This brush drawing must have been executed while Shahn was conceiving the painting SPRING (1947) (Albright-Knox Art Gallery). The postures of the two figures in the final painting are similar to those in the sketch, but viewed from a different angle.

14 / Study for Red Staircase No. 1, 1944
Watercolor on paper, 5 x 6¼ inches

This study, in ink with a wash of blue, is of the central figure in THE RED STAIRWAY (1944). The figure, a cripple, is futilely climbing a set of stairs which lead nowhere. The painting for which this study was painted is now in the collection of the St. Louis City Art Museum.

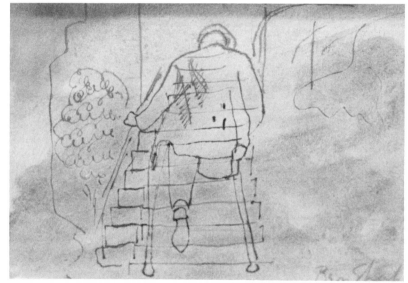

51

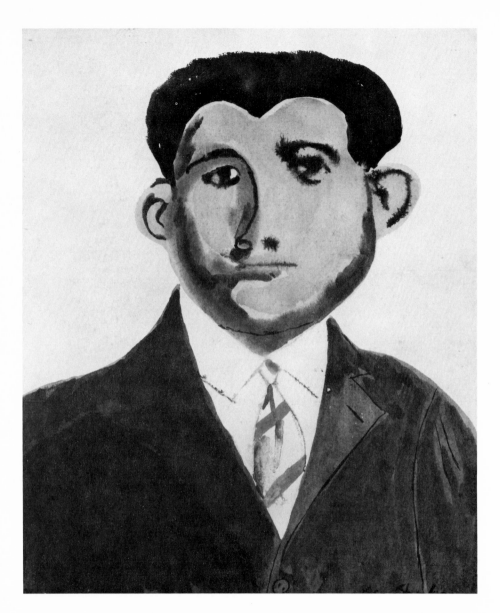

15 / *Witness Enrico Bastorie*
(Sacco & Vanzetti Series) c. 1931-32
Tempera on paper, 10 x 8½ inches

This portrait of one of the witnesses in the Sacco and Vanzetti case,
based on a newspaper photograph, is one of a series of twenty-three
paintings on the characters and events relating to the controversial case.

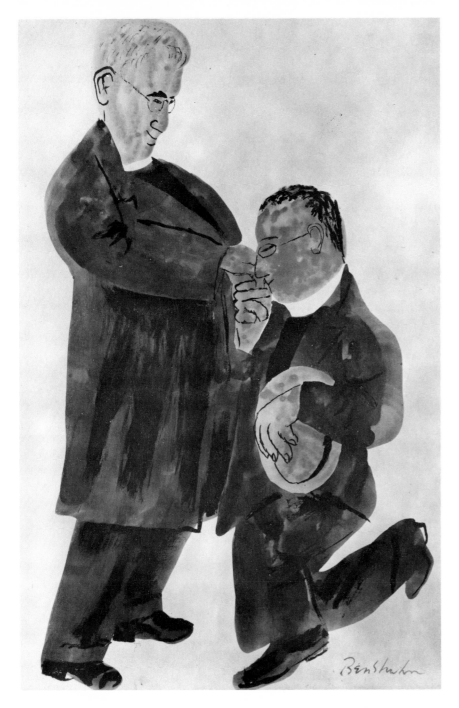

16 / *Father Coughlin*, 1943
 Gouache on paper, 18 x 11½ inches

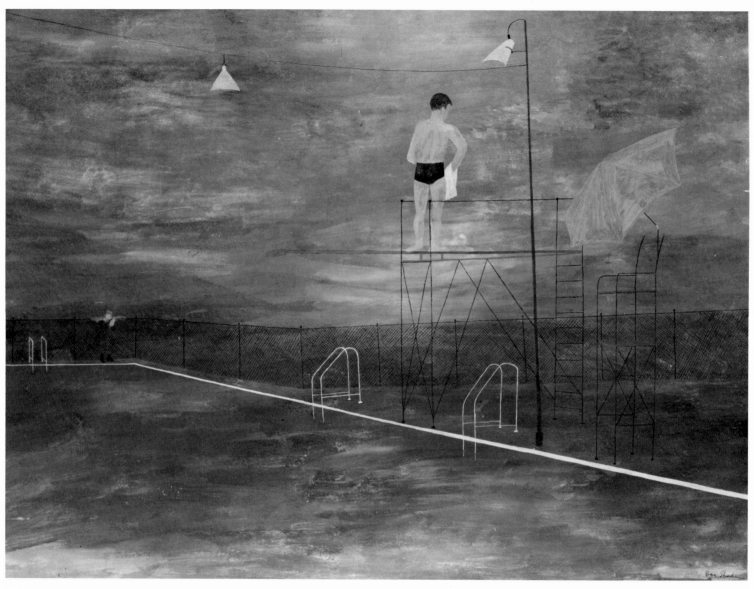

17 / *Swimming Pool*, 1945
Tempera on illustration board,
22 x 30 inches

This moving tempera has been chosen to represent Ben Shahn in such exhibitions as "Ben Shahn – Paintings & Graphics," Santa Barbara Museum of Art, California, 1967; "Ben Shahn Retrospective Exhibition," National Museum of Modern Art, Tokyo, 1970; A Ben Shahn Retrospective at the New Jersey State Museum, Trenton, 1969; and "The American View," Charles H. MacNider Museum, Mason City, Iowa, 1979.

18 / *Basketball Players, 1940-42*
Tempera on academy board, 8¾ x 13½ inches
(Study for Federal Security Building)

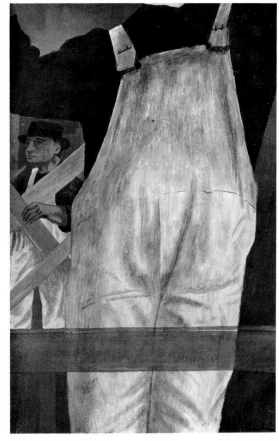

The building at the top of the composition and the three middle figures playing handball against the concrete wall are also found in HANDBALL *(1939), The Museum of Modern Art. Shahn incorporated images from previous easel paintings into the mural at the Federal Security Building (formerly Social Security Building).*

19 / *Carpenter No. 2, 1940-42*
Gouache on board, 12 x 8 inches
(Study for Federal Security Building)

This is also a study for the mural at the Federal Security Building. New motifs, like these carpenters in their white overalls, were interwoven with the images from previous paintings, such as the handball players and the WILLIS AVENUE BRIDGE *figures.*

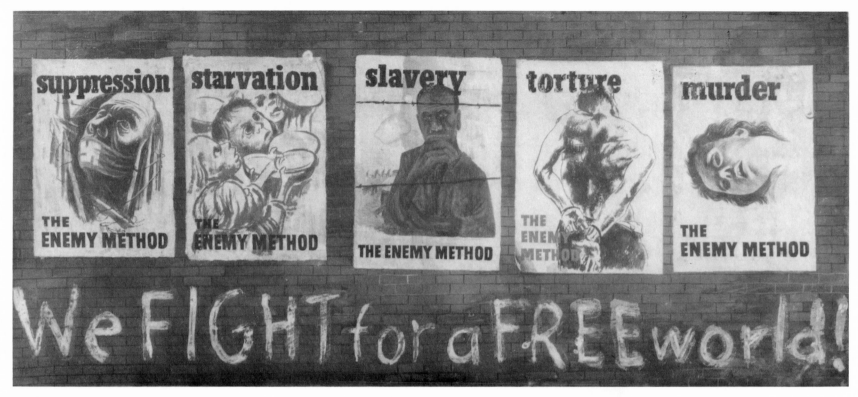

20 / We Fight for a Free World
 Gouache on board, 13½ x 29¾ inches

Shahn worked as a Senior Liaison Officer for the Graphics Division of the Office of War Information in 1942-43. He produced a number of effective posters, but only two of them were actually published. So exceptional were Shahn's design and typography sense that he was appointed Director of the Graphic Arts Division of the Congress of Industrial Organizations. Here he continued to produce many compelling posters.

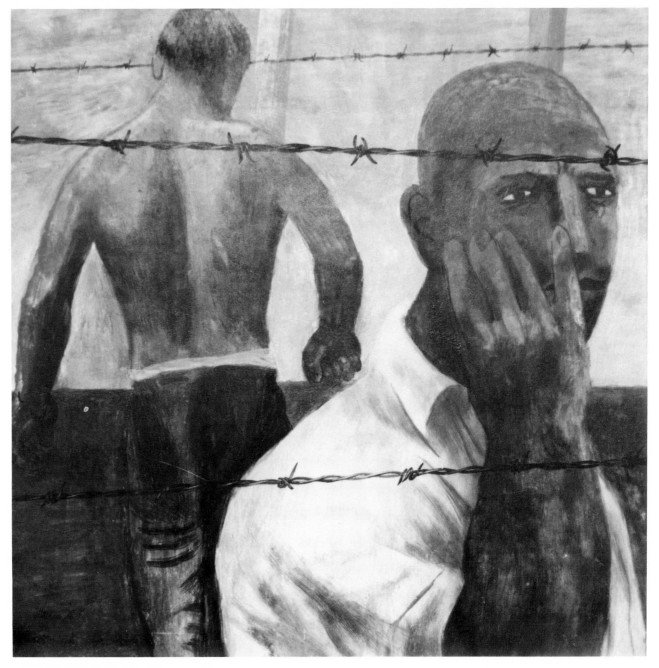

21 / *Concentration Camp*, 1944 Tempera, 24 x 24 inches Collection of Mr. & Mrs. Jacob Schulman

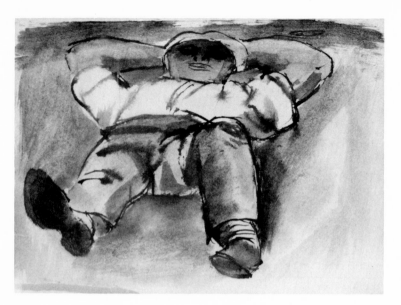

22 / *Man Resting with Hands Behind His Head*, c. 1933-35
Watercolor on paper, 5 x 7 inches

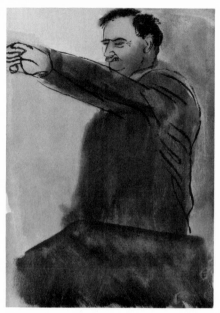

23 / *Man with Arm Extended*, c. 1933-35
Watercolor on paper,
7 x 5 inches

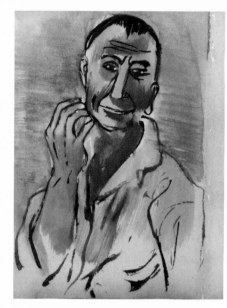

24 / *Study of Man's Face*, c. 1933-35
Watercolor on paper,
7 x 5 inches

In 1934 Ben Shahn and Lou Block were commissioned by the Federal Emergency Relief Administration to enliven the walls of the steel block prison on Rikers Island, New York. Block and Shahn worked from May 1934 to June 1935 snapping photographs and sketching scenes from prisons all over the state.

Although approved by the mayor and commissioner of corrections, the final completed sketches were rejected by the Municipal Art Commission on the grounds they were "unsuitable for the location for which they were intended." The prisoners, it was felt, saw enough of prison life without repeating such scenes upon their walls. The six studies pictured above are from a small sketch book of preparatory drawings for the projected mural.

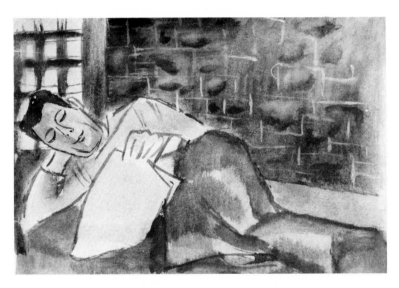

25 / Man Reading, c. 1933-35
Watercolor on paper, 5 x 7 inches

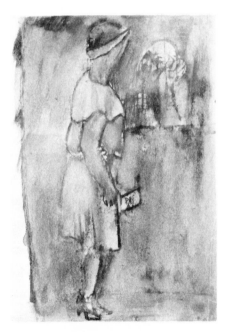

26 / Woman Talking with Prisoners,
c. 1933-35
Watercolor on paper,
7 x 5 inches

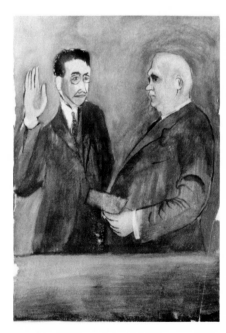

27 / Judge Swearing In Man,
c. 1933-35
Watercolor on paper,
7 x 5 inches

59

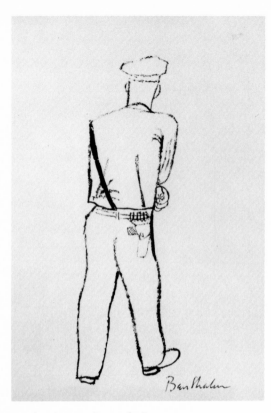

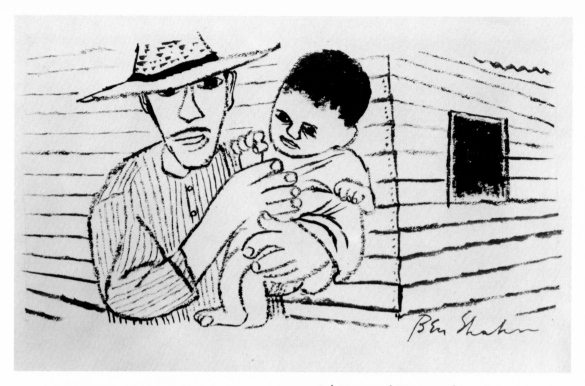

28 / *Farmer and Son*, c. 1936
 Ink and brush drawing, 5¾ x 7¾ inches

30 / *Policeman from Behind*, c. 1947
 Ink drawing, 6¼ x 4¼ inches

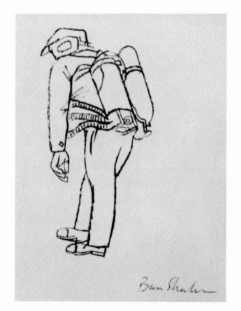

29 / *Rescue Worker*
 Ink drawing, 4¼ x 3¼ inches

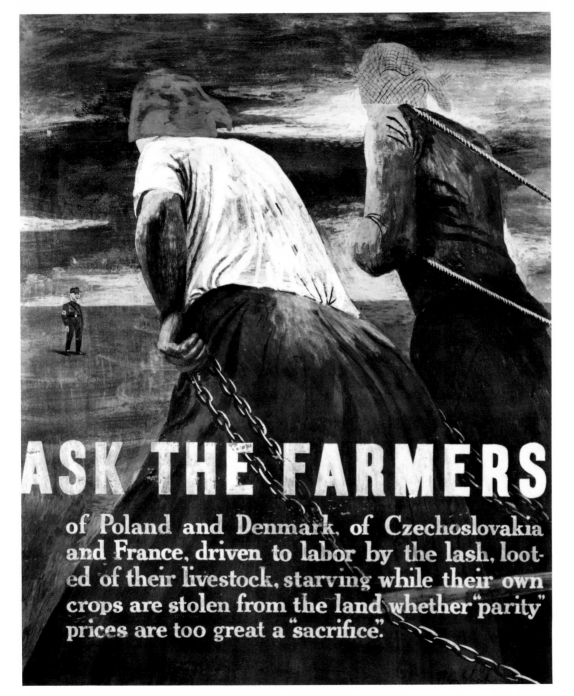

ASK THE FARMERS

of Poland and Denmark, of Czechoslovakia and France, driven to labor by the lash, looted of their livestock, starving while their own crops are stolen from the land whether "parity" prices are too great a "sacrifice."

33 / *Study for* Fallout II, 1957
 Ink and brush drawing, 7½ x 10 inches

32 / *Scientist*, 1957
 Ink and brush drawing, 5½ x 4¾ inches

34 / *The Scientist*, 1957
Ink and brush drawing, 6½ x 9½ inches

35 / *News Bulletin No. 2*, 1957
Ink and brush drawing, 5½ x 6½ inches

In 1957 Shahn did a series of drawings on the Lucky Dragon incident
to illustrate Ralph E. Lapp's article in HARPER'S magazine. Later
some of these drawings were published in the 1965 book, KUBOYAMA
AND THE SAGA OF THE LUCKY DRAGON by Richard Hudson.

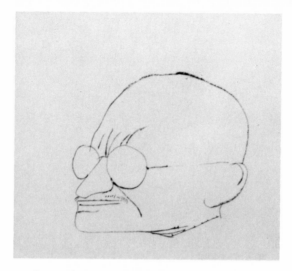

37 / *Gandhi (Face Study)*, 1965
Ink and brush drawing, 7½ x 8¾ inches

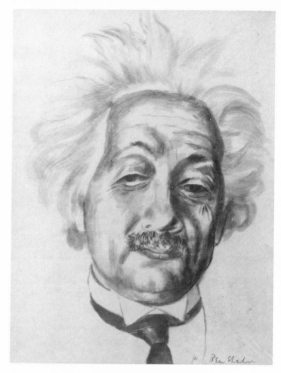

38 / *Albert Einstein*, 1937
Ink and brush drawing, 23½ x 18¼ inches

36 / *Barry Goldwater*, c. 1964
Ink and brush drawing, 19 x 14 inches

Senator Barry Goldwater is depicted in this drawing as a babe in swaddling clothes, putting his foot in his mouth. Shahn used this same image in an anti-Goldwater poster during the Johnson–Goldwater presidential campaign. Another campaign poster featured just the face from this drawing.

Shahn illustrated the article by Leo Rosten on Gandhi in a 1964 issue of LOOK MAGAZINE. *Three print versions of the drawing were later produced. This brush drawing is a study of the head of Gandhi for this drawing. The final version is virtually the same, with the addition of details in the eyes, ear and mustache.*

Shahn spent several sessions with Dr. Albert Einstein making a number of portrait drawings of the great physicist.

64

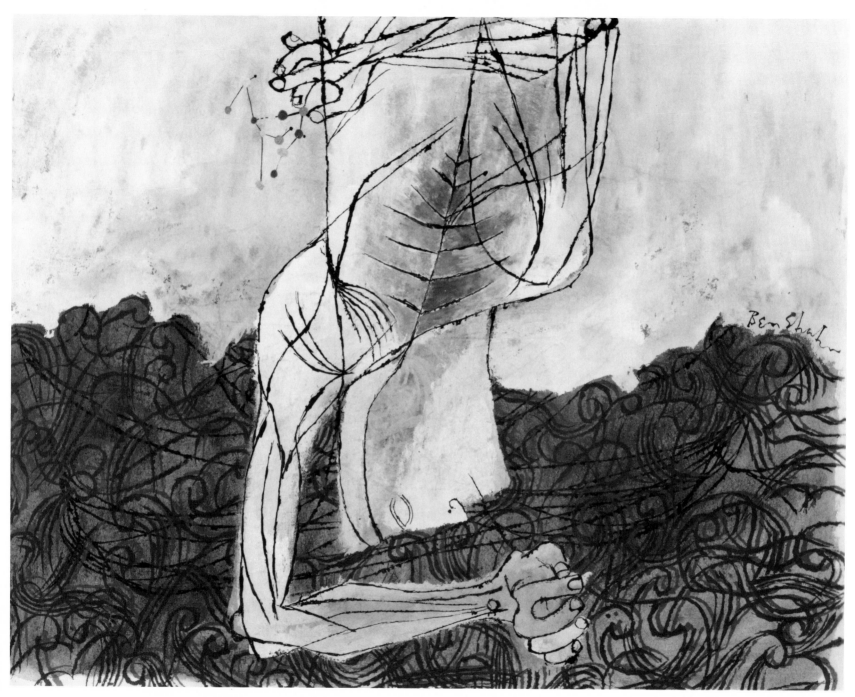

39 / *The Fall*, 1957 Gouache on paper, 19¾ x 25¾ inches

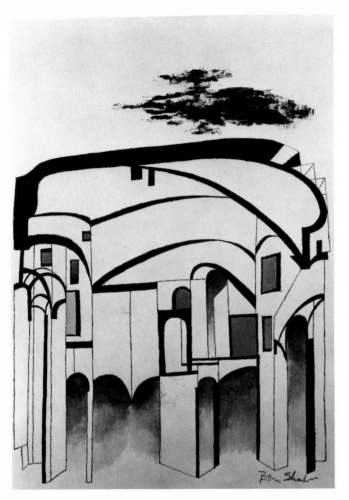

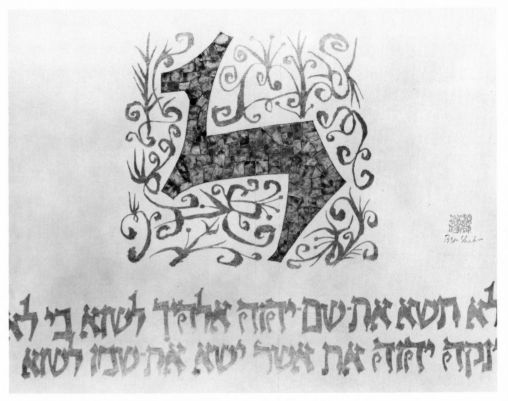

41 / *Third Commandment*, 1965
Watercolor and gold leaf on paper, 26 x 36 inches

40 / *Byzantine Memory*, 1966
Gouache on paper, 26½ x 19½ inches

The intricate, oriental-feeling in the structure shown in this painting is a motif found in several works between 1951 and 1968. This version was reproduced in a serigraph of the same title in 1966.

66

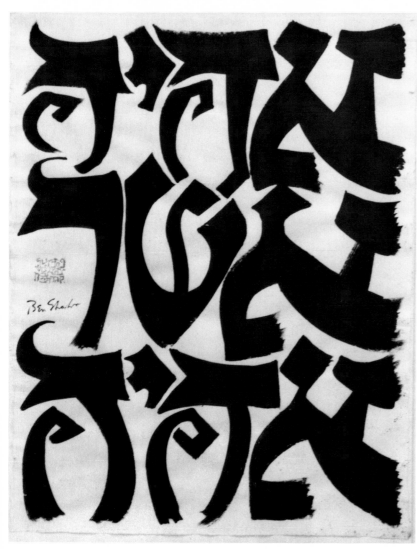

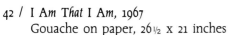

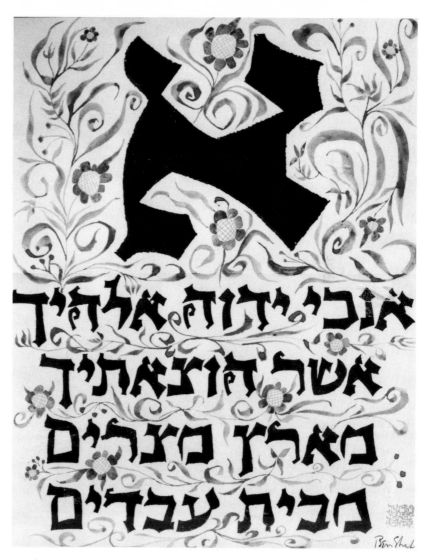

42 / *I Am That I Am*, 1967
Gouache on paper, 26½ x 21 inches

43 / *First Commandment*
Watercolor and gold on paper, 32 x 26 inches

Calligraphy has always been an important aspect of Ben Shahn's art. His seventeen years of experience as a lithographer taught him much about the special skills involved in shaping and spacing letters. Shahn studied folk alphabets during his travels and often photographed signs and billboards exhibiting different lettering styles. The Hebrew and Chinese styles of calligraphy also influenced Shahn's lettering techniques. Shahn developed his own imaginative rendition of the Hebrew alphabet, as illustrated in the three paintings THE THIRD COMMANDMENT (1965), I AM THAT I AM *(1967)* and THE FIRST COMMANDMENT.

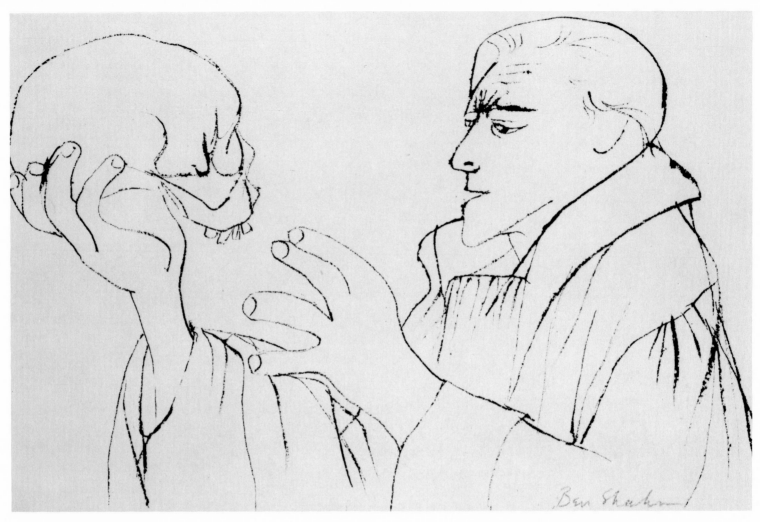

44 / Alas Poor Yorick, 1959
 Ink and brush drawing, 6¾ x 10 inches

In 1959 Shahn completed a series of drawings for Columbia Broadcast System's "Hamlet: A Television Script." Shahn's love of Shakespeare began as a youth when the local librarian gave him a volume of Shakespeare to read. He memorized the verses out loud – a technique he had picked up from his grandfather in Lithuania – as he ground down the stones at the lithography studio.

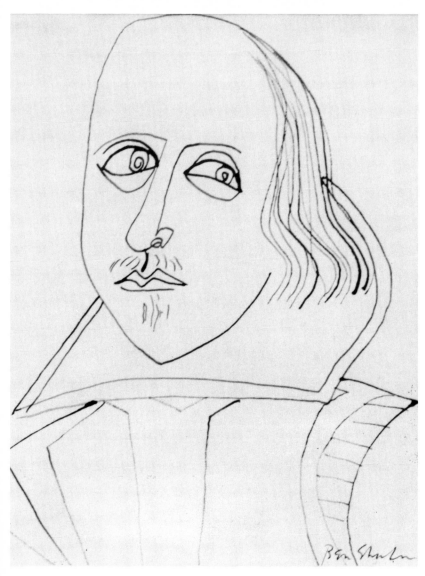

45 / *Bust of Shakespeare*, c. 1959
Ink and brush drawing, 11½ x 9 inches

46 / *Gertrude, Ophelia's Funeral*, 1959
Ink and brush drawing, 7 x 5¼ inches

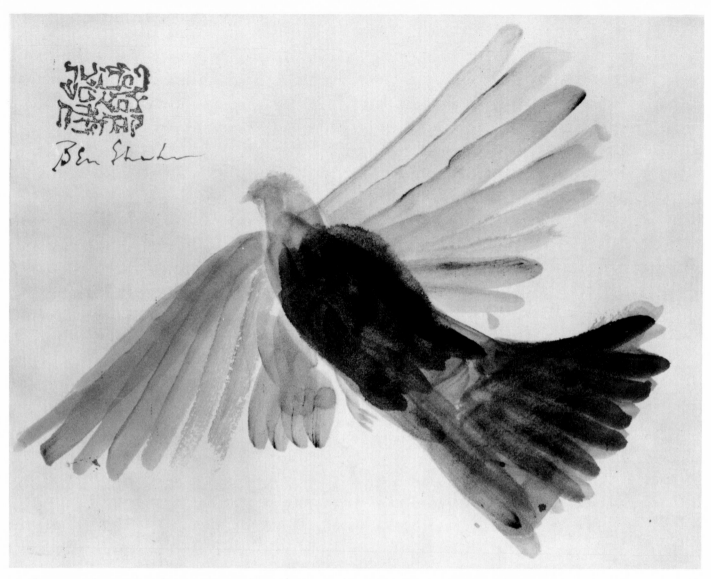

47 / *Dove, One of a Score,* 1961
 Watercolor on paper, 10 x 13 inches

From the Lucky Dragon series of paintings, DOVE, ONE OF A SCORE *symbolizes the flight of pigeons released by Japanese students at the end of the funeral for Aikichi Kuboyama, radio man on the "Lucky Dragon."*

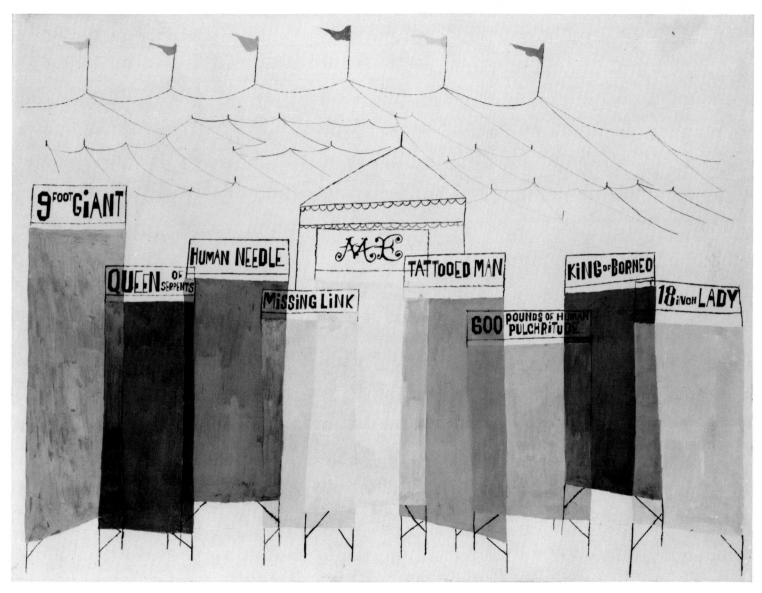

48 / *Carnival Scene, 1950*
 Gouache on paper, 18¾ x 26 inches

The image of the gaily colored circus booths lined up in a row is also used in ANATOMICAL MAN *(1949),* TROUBLE *(1947) and* DESERTED FAIRGROUND *(1947), where it takes on an almost sinister quality.*

49 / *Love Sonnet: Set Me Whereas..., c. 1964*
Watercolor on paper, 7 x 12 inches

Shahn created decorations, end papers and seventeen small paintings as illustrations for the anthology LOVE SONNETS *(Vineyard Books, Inc., 1964, 1974), selected and with notes by Louis Untermeyer. On the reverse side of these paintings is the hand-lettered love sonnet that the painting illustrates. Both the pictures and letterings were reproduced in this beautifully designed book.* SET ME WHEREAS *is found on page 11,* I CRY YOUR MERCY *on page 31 and* WHEN MEN SHALL FIND *appears on page 23 of the 1974 edition.*

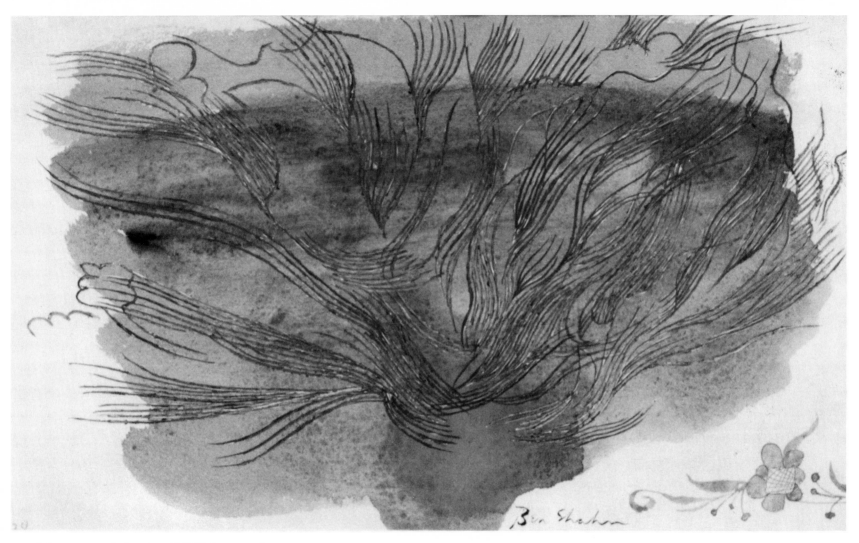

50 / *Love Sonnet: When Men Shall Find...*, c. 1964
 Watercolor on paper, 7¾ x 12½ inches

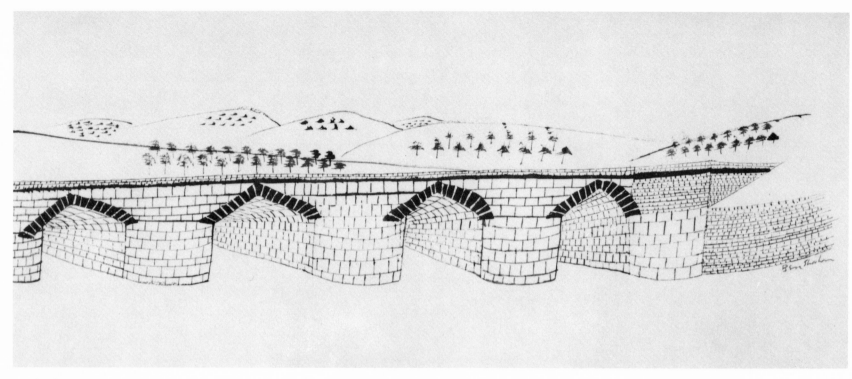

51 / *The Bridge*
 Ink and brush drawing, 9 x 23 inches

The bridge in this ink brush drawing is almost identical to the bridge found in the background of ITALIAN LANDSCAPE, I *(1944), painted in sympathy for the suffering brought about by the war in Europe. A looser, more abbreviated version of this bridge illustrates Ben Shahn's book,* THE SHAPE OF CONTENT *(Vintage Books). This book, first published in 1957, contains the Charles Eliot Norton Lectures given by Ben Shahn in 1956-57. Students today still read and study this statement on art.*

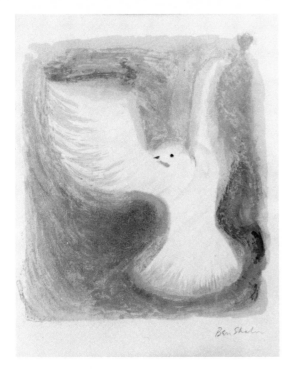

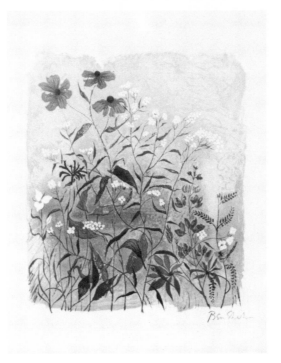

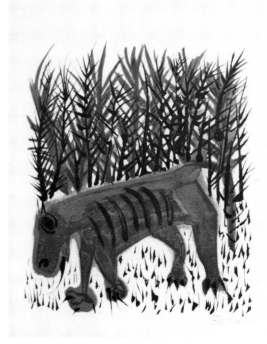

52 / *How the Birds Fly*, c. 1968
(Rilke Portfolio)
Lithograph in colors, 22½ x 17¾ inches

53 / *The Gestures of the Little Flowers*, 1968
(Rilke Portfolio)
Lithograph in colors, 22½ x 17¾ inches

54 / *One Must Know the Animals*, 1968
(Rilke Portfolio)
Lithograph in black and grey,
22½ x 17¾ inches

The year before his death Shahn created perhaps his most beautiful and moving portfolio of lithographs. FOR THE SAKE OF A SINGLE VERSE, *The Rilke Portfolio, is based on a quotation from Rainer Maria Rilke's* NOTEBOOKS OF MALTE LAURIDS BRIGGE. *Two hundred Rilke portfolios were printed by Atelier Mourlot Ltd., New York, from zinc plates on Richard de Bas handmade paper, and signed by the artist. An additional edition of 750 were signed on the plates only, and printed on Velin d'Arches paper.*

The portfolio includes an unsigned headpiece and twenty-three signed lithographs. Each lithograph is accompanied by the corresponding quote from Rilke.

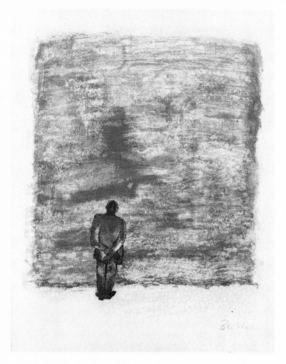

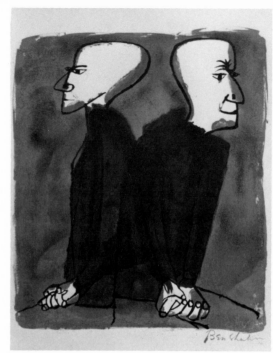

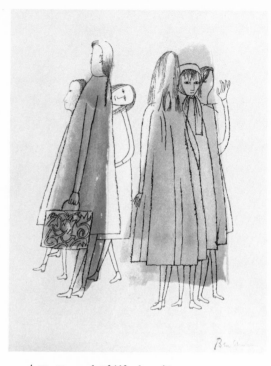

55 / *Mornings by the Sea*, 1968
(Rilke Portfolio)
Lithograph in colors, 22 ½ x 17 ¾ inches

56 / *Partings Long Seen Coming*, 1968
(Rilke Portfolio)
Lithograph in colors, 22 ½ x 17 ¾ inches

57 / *To Days of Childhood*, 1968
(Rilke Portfolio)
Lithograph in colors, 22 ½ x 17 ¾ inches

58 / *Many Men*, 1968
(Rilke Portfolio)
Lithograph in black and grey,
22½ x 17¾ inches

59 / *In Rooms Withdrawn and Quiet*, 1968
(Rilke Portfolio)
Lithograph in colors, 22½ x 17¾ inches

NEW YORK PHOTOGRAPHS

60 / *8th Ave and 42nd Street. 2 Circus Men*
Vintage Photograph, c. 1930s

Burlesque / 61
Vintage Photograph, c. 1930s

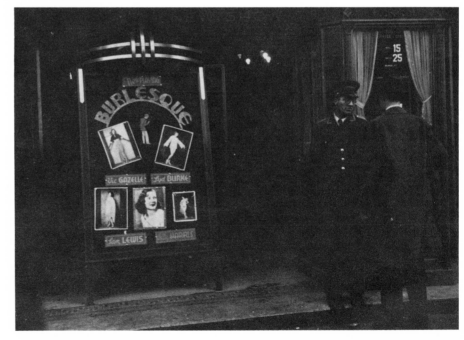

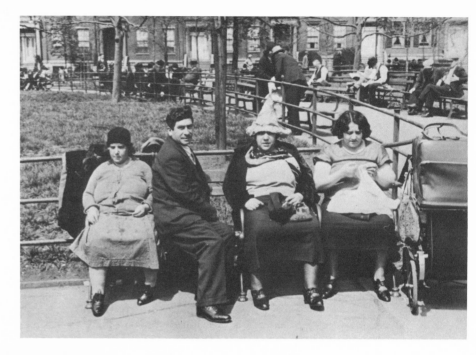

Washington Square - North / 63
Vintage Photograph, c. 1930s

The ludicrous fat lady in the folded newspaper hat of this photograph becomes the central figure in the sardonic painting NEARLY EVERYBODY READS THE BULLETIN *(1946).*

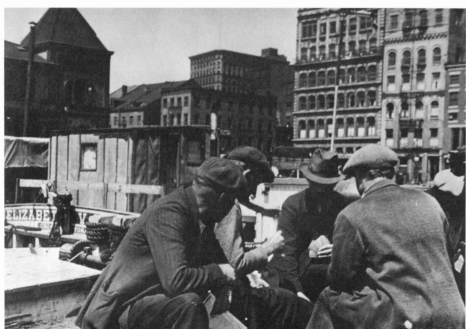

62 / *Card Game*
Vintage Photograph, c. 1930s

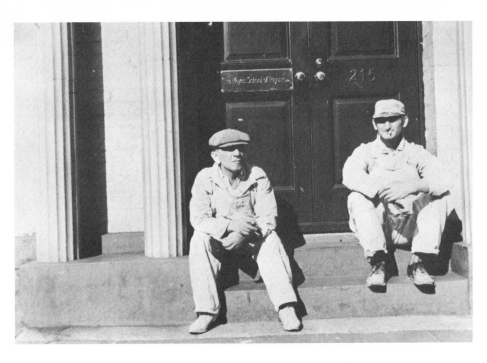

64 / 215; *Noyes School of Rhythm*
Vintage Photograph, c. 1932

Polar Plant Ford / 65
Vintage Photograph, c. 1930s

Shahn used the two seated men, crumpled newspaper on a chair and the scratched wall in his painting SPRING (DEMOCRACIES FEAR PEACE OFFENSIVE), *(1940). The only difference between the photograph and the painting is the addition at the top of the painting of the same section of the building found in* HANDBALL *and Sketch for Federal Security Building (*BASKETBALL PLAYERS*), and the change of headline from "Polar Plant Ford" to "Democracies Fear New Peace Offensive."*

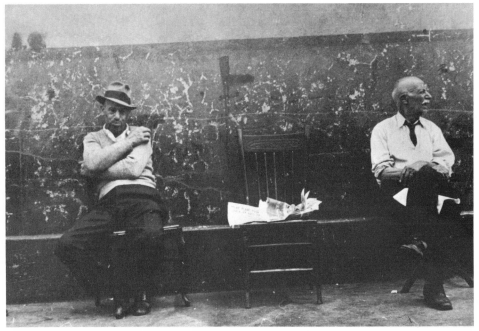

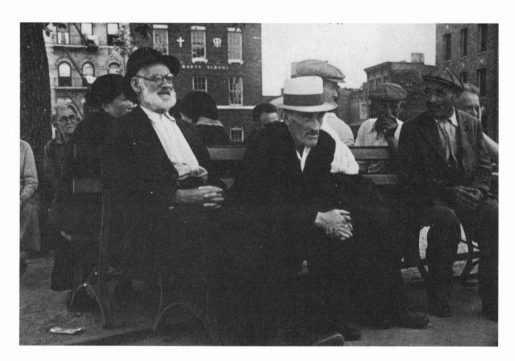

On the Park Bench in Front if St. Mary's / 67
Vintage Photograph, c. 1930s

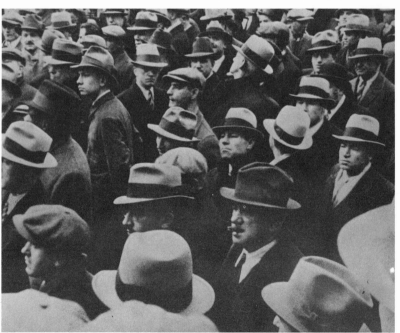

66 / *Hats (horizontal)*
Vintage Photograph, c. 1932

The middle section of this photograph became the tempera
CROWD LISTENING *(1936)*.

68 / *Seward Park, New York, or,*
Two Men With Hats, Two Without
Vintage Photograph, c. 1933

The listlessness of the unemployed as revealed in this photograph is the topic for Shahn's first print, a lithograph entitled, SEWARD PARK *(1936)*

Group of Prisoners / 69
Vintage Photograph, c. 1934

Shahn photographed this group of prisoners at the New Hampton Reformatory, New York, while visiting state prisons in preparation for the projected Rikers Island murals.

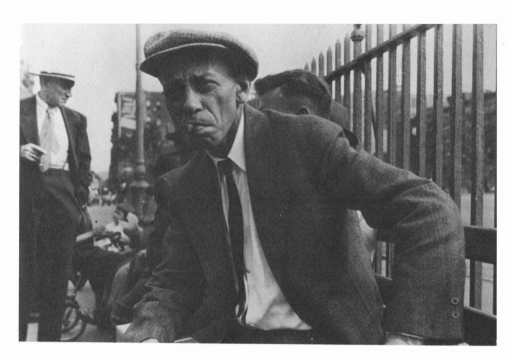

Seward Park / 70
Vintage Photograph, c. 1933

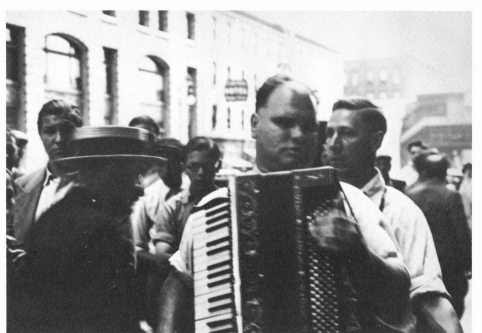

71 / Blind Accordian Player
Vintage Photograph, c. 1945

Shahn poignantly captures the grief of a blind accordian player during the mourning parade following Roosevelt's death in 1945. This grieving musician became the subject for the painting THE BLIND ACCORDIAN PLAYER (1945).

72 / *Albany Street*
Vintage Photograph, c. 1932

Seurat's Lunch – West Side / 73
Vintage Photograph, c. 1930s

SEURAT'S LUNCH – WEST SIDE *served as the model for the tempera*
SEURAT'S LUNCH *(1939). Almost every detail in the photograph*
is recreated in the painting.

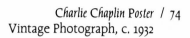

Charlie Chaplin Poster / 74
Vintage Photograph, c. 1932

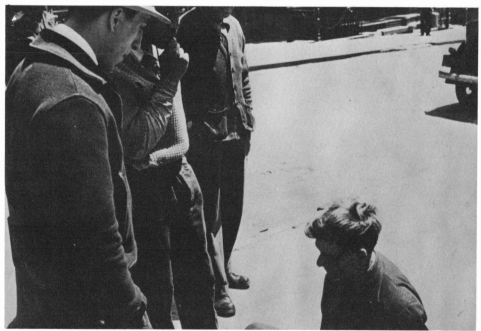

75 / *Accident*, signed in ink
Vintage Photograph, c. 1930s

86

76 / Four Men Behind Fence, Seward Park.
Vintage Photograph, c. 1930s

We Can't Eat It? / 77
Vintage Photograph, c. 1930s

Figures such as these appear in Shahn's painting of the Parade for
Repeal, from the Prohibition Series of 1933-34.

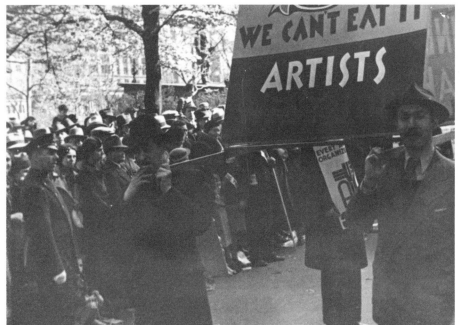

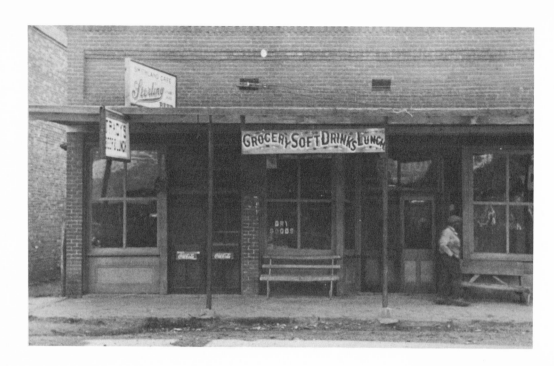

78 / Grocery, Soft Drinks, Lunch
Vintage Photograph, c. 1935-36

Laundry on Vacant Lot / 79
Vintage Photograph, c. 1933

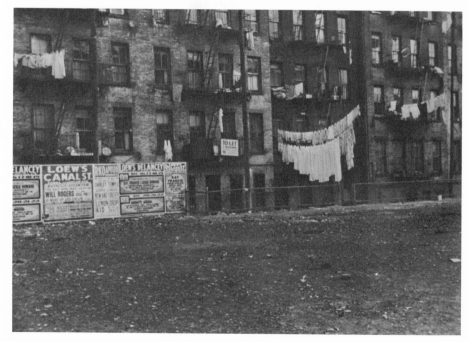

JOHN CANADAY

John Canaday is an art critic, art historian and renowned author. He was the art critic for *The New York Times* from 1959 to 1976. He also taught Art History in several universities across a span of twenty years and was an educational administrator for the Philadelphia Museum of Art. Mr. Canaday is the author of several volumes of art history, criticism and essays as well as two series of twelve monographs for the Metropolitan Museum of Art. His *Mainstreams of Modern Art*, 1959, is widely used as a college text. Mr. Canaday's most recent book, *What is Art?*, is a clear, entertaining and authoritative sampling of the world's greatest works of art.

DR. KENNETH W. PRESCOTT

Dr. Kenneth W. Prescott, Guest Curator, is currently Department Chairman and Professor of Art at the University of Texas in Austin. He was formerly the director of the New Jersey State Museum, Trenton, and Program Officer for the Visual Arts, Ford Foundation, New York. Dr. Prescott has been instrumental in organizing Ben Shahn exhibitions at the Jewish Museum National Museum of Modern Art in Tokyo and others. He is the author of several books on Shahn, Domjan, Levine and Diller, including *The Complete Graphic Works of Ben Shahn*, 1973. His latest book, *Posters and Prints of Ben Shahn*, is slated for publication by Dover in January 1982.

JACOB SCHULMAN

Jacob Schulman is the senior partner of Jacob Schulman & Company, Certified Public Accountants, Gloversville, New York. Mr. Schulman has been a collector for over twenty-five years of 20th century American Art with emphasis on Biblical and Jewish themes. A strong part of his collection embraces drawings, gouaches and temperas by Ben Shahn. Many of these paintings have been exhibited in the Museum of Modern Art, the Jewish Museum, the Israel Museum and other major museums and universities. In 1968 Mr. Schulman was actively involved in installing a mosaic, Ben Shahn's *The Passion of Sacco and Vanzetti*, on the campus of Syracuse University, Syracuse, New York.

MARTHA FLEISCHMAN

Martha Fleischman, daughter of Lawrence A. Fleischman, Director of Kennedy Galleries, is a second generation member of the noted Kennedy Galleries staff. She began working at the Galleries at age fourteen. Ms. Fleischman is a graduate of Sarah Lawrence College and has also worked at the Metropolitan Museum of Art. She has been responsible for numerous exhibitions at the Galleries including important shows by Elihu Vedder and Abraham Rattner. Ms. Fleischman feels particularly close to the master works of Ben Shahn because of personal ties between the Fleischman and Shahn families.

SELECTED CHRONOLOGY OF BIOGRAPHICAL DATA

1889 Born, September 12, in Kovno, Lithuania (today a part of the U.S.S.R.).

1906 Immigrates with family to United States; lives in Brooklyn, New York.

1913 Apprentices with a lithographer (Hessenberg, Manhattan).

1919–1922 Attends New York University and wins two summer scholarships to Marine Biological Laboratory, Woods Hole, Massachusetts. Attends City College of New York. Continues working as journeyman lithographer throughout to support his education.

1922 Studies at National Academy of Design and Art Students League. Executes student mural on restaurant wall in exchange for meals.

1925 Travels to Europe with first wife, Mithilda Goldstein Shahn. Studies French at Sorbonne and art at Academmie de la Grande Chaumiere while living in Paris. Travels to North Africa, Spain, Italy, Austria and Holland.

1927 Returns to North Africa, especially the Island of Djerba, and to Europe. Witnesses and joins demonstrations in behalf of Sacco and Vanzetti who were condemned to death in Massachusetts.

1929 Returns to United States in September at the time of the Stock Market Crash.

1930 First one-man exhibition at the Downtown Gallery, New York. The show, "Painting and Drawing, Ben Shahn," concentrates on African subjects. Paints the Dreyfus Series: thirteen gouaches depicting the participants in the Dreyfus case. Exhibits this series with photographs by Walker Evans in a neighbor's barn in Truro, Massachusetts.

1931 Paints a series of 23 temperas on the trial and execution of Nicola Sacco and Bartolomeo Vanzetti.

1932 Exhibitions of the Sacco and Vanzetti series at the Downtown Gallery, New York, and at the Harvard Society of Contemporary Art, Cambridge, Massachusetts.

1932–1933 Exhibition of fifteen paintings on the case of Tom Mooney at the Downtown Gallery, New York. Diego Rivera admires these works and hires Shahn as his mural assistant at Rockefeller Center, New York.

1933–1934 Begins photographing New York street scenes with the help of photographer Walker Evans. Paints eight temperas on Prohibition, studies for projected mural at Central Park Casino.

1935–1936 Joins Resettlement Administration, Special Skills Staff, as photographer to document poverty in rural America for the Resettlement Administration File. Photographs from these files are included in a group photographic exhibition at WPA Federal Art Project Gallery, New York, in December 1936.

1935–1938 Works for Farm Security Administration as artist, designer and photographer. Takes series of photographs of Ohio rural and small-town life.

1937 Paints a series of gouache studies for submission to a mural competition for the Town Hall of a new community near Milwaukee, Wisconsin, which are rejected. Paints tempera study, *The Great State of Wisconsin* for the existing mural in the Health, Education and Welfare Building, Washington, D.C.

1937–1939 Commissioned by Farm Security Administration to paint a fresco for the Community Center at Roosevelt, New Jersey. Executes thirteen large mural panels with his second wife, Bernarda Bryson, for the main lobby of the Bronx Central Annex Post Office, New York.

1942–1943 Works as Senior Liaison Officer, Graphics Division, Office of War Information. Designs posters for the OWI, two of which are published. Represented by eleven works in "American Realists and Magic Realists" at the Museum of Modern Art, 1943. Produces the *Welders* poster for the Political Action Committee of the CIO. Begins commercial commissions for Container Corporation of America, CBS, Columbia Records and many magazines.

1945 Becomes the chief artist of the graphics arts division of the CIO. Designs posters, pamphlets, etc.

1947–1948 Show of sixteen works circulated in England by the Arts Council of Great Britain. A retrospective exhibition at the Museum of Modern Art. Penguin Books publishes a monograph, *Ben Shahn*, by James Thall Soby. *Look* magazines names Shahn as one of the ten leading American painters as a result of a poll of Museum directors.

1954 Represents the United States in XXVII Venice Biennale, along with William De Kooning.

1955 Accepts an invitation to serve as Charles Elliot Norton Professor of Poetry at Harvard University, 1956-57.

1956 Receives Joseph E. Temple Gold Medal Award from the Pennsylvania Academy of Fine Arts and is elected to National Institute of Arts and Letters.

1957 Harvard University Press publishes *The Shape of Content*. Shahn designs and illustrates *Homage to Mistress Bradstreet*, by John Berryman. The Institute of Contemporary Art, Boston, prepares an exhibit documenting the several aspects of Shahn's work.

1958 Awarded the American Institute of Graphic Arts Gold Medal. Designs and illustrates Alastair Reid's book, *Ounce Dice Trice*.

1959 Exhibitions in Rome and London. Completes a series of drawings for CBS' *Hamlet: A Television Script*.

1960 Begins the *Lucky Dragon* series of paintings. Resumes travel and photography. Awarded the Society of Illustrators' Medal.

1961 The International Council of the Museum of Modern Art prepares a retrospective exhibition, "Ben Shahn," to tour Amsterdam, Brussels, Rome and Vienna.

1962 Helps to establish Roosevelt Memorial Park. Makes posters for Lincoln Center for the Performing Arts and the Boston Arts Festival. One man exhibition, selected from the Museum of Modern Art, tours West Germany, Yugoslavia, Sweden and Israel. Awarded honorary Doctor of Fine Arts degree by Princeton University.

1963 Writes *Love And Joy About Letters*. Illustrates and hand-letters NOVEMBER TWENTY SIX NINETEEN HUNDRED SIXTY-THREE, a book in memory of the assassination of President Kennedy, poem by Wendell Berry.

1964 Completes paintings for *Love Sonnets*, selected and with notes by Louis Untermeyer. Italian translation of *The Shape of Content* is published as is a Japanese edition of *Love and Joy About Letters*. Receives numerous awards and honorary degrees.

1965 Publication of *Kuboyama and the Saga of the Lucky Dragon*, by Richard Hudson and Ben Shahn. With Architect Max Abramovitz, creates stained glass windows for Temple Beth Zion, Buffalo, New York.

1966 Publication of *Haggadah* with pages executed in 1931, in a Deluxe Edition by Trianon Press, Paris.
Lecture, "In Defense of Chaos," delivered at International Design Conference.

1967 Sacco and Vanzetti mosaic mural installed on east wall of Huntington Beard Crouse Building
of Syracuse University. Drawing of Gandhi published in *The New York Times* December 31.
Receives awards and honorary degrees. Retrospective exhibition at Santa Barbara Museum of Art,
travels to La Jolla and Indianapolis.

1968-1969 Produces a series of original color lithographs with Henri Deschamps of the Inprimerie Moulot of
Paris for the Portfolio, *For the Sake of a Single Verse*, based on a passage from a Rainer Maria Rilke's
The Notebooks of Malte Laurids Brigge. Creates a series of drawings to be lithographed based on Psalm 150.

1969 Dies March 14, 1969.

SELECTED POSTHUMOUS EXHIBITIONS

1969 Museum of Modern Art, New York, "Homage to Ben Shahn."
New Jersey State Museum, Trenton, "Ben Shahn: A Retrospective Exhibition."
Fogg Art Museum, Cambridge, Mass., "Ben Shahn as Photographer."
Kennedy Galleries, New York, "Ben Shahn 1898-1969."
Ankrum Gallery, Los Angeles.

1970 Nantenshi Gallery, Tokyo, "Ben Shahn."
Exhibition of "Ben Shahn " travels to Kurume, Tokyo, Sapporo, Osaka and Hiroshima.
Kennedy Galleries, New York, "The Drawings of Ben Shahn."

1972 Art Center, New School for Social Research, New York, "Human Satire and Irony."
Brooklyn Museum, Brooklyn, "A Century of American Illustration."

1975 The Jewish Museum, New York, "Jewish Experience in the Art of the Twentieth Century."

1976 Hirshhorn Museum and Sculpture Garden of the Smithsonian Institution, Washington, D.C., "The Golden Door, Artist-Immigrants of America 1876–1976."
Grey Art Gallery, New York University, New York, "Images of an Era; The American Poster 1945–1975."
Kennedy Galleries, New York, "The Drawings of Ben Shahn."

1976–1977 "Retrospective 1898–1969," The Jewish Museum, New York, travelling to Georgia Museum of Art, Athens, Georgia; The Maurice Spertus Museum of Judaica, Chicago, Illinois; University Art Museum, University of Texas, Austin, Texas; Cincinnati Art Museum, Cincinnati, Ohio; Amon Carter Museum, Fort Worth, Texas.

1979 Kennedy Galleries, New York, "Ben Shahn Drawings."

1980 "Homage to Ben Shahn, A Parco Exhibition," an exhibition travelling throughout Japan.

1981 Temple Emmanu El, Houston, Texas, "Ben Shahn: Images And Concepts."

1981 Santa Fe East, Santa Fe, New Mexico, "Ben Shahn: Voices And Visions."

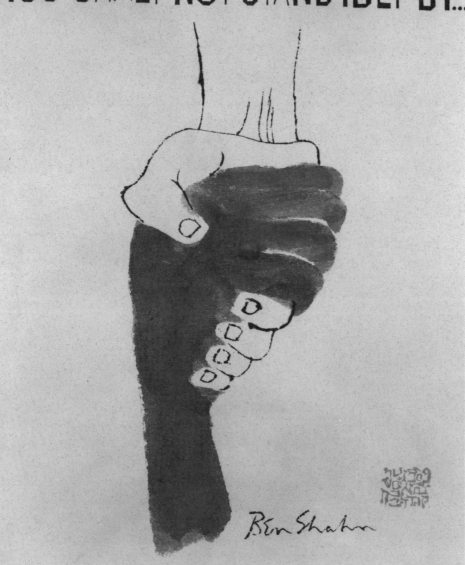

לא תעמד על-דם רעך

"THOU SHALT NOT STAND IDLY BY..."

Ben Shahn

80 / *Thou Shall Not Stand Idly By*, 1965
Ink and gouache on paper,
22 x 17 inches

VOICES AND VISIONS

Printed in an edition of 2,250

of which 250 copies

are especially bound and slipcased.

The limited edition

is numbered and signed by the authors.